ROMFORD
HISTORY TOUR

To Michael Mulheron, a very special brother

First published 2017

Amberley Publishing
The Hill, Stroud,
Gloucestershire, GL5 4EP
www.amberley-books.com

Copyright © Michael Foley, 2017
Map contains Ordnance Survey data
© Crown copyright and database right
[2017]

ISBN 978 1 4456 7728 6 (print)
ISBN 978 1 4456 7729 3 (ebook)

British Library Cataloguing in
Publication Data.
A catalogue record for this book is
available from the British Library.

Origination by Amberley Publishing.
Printed in Great Britain.

INTRODUCTION

Romford has a long history that streches back into the distant past. The original site of the town was at Oldchurch where the hospital once stood. It was moved in medieval times to avoid the constant flooding that occurred there. It has always been known as a market town but its growth was also due to it being on the road to London from East Anglia and Colchester, which led to its development as a coaching stop.

It did have other historical connections, especially military ones. A cavalry barracks was built there during the Napoleonic Wars next to what was Dog Lane but later became Waterloo Road. One famous resident at the barracks was Lord Cardigan, who led the Charge of the Light Brigade when he first joined the army. In the First World War there were a number of military camps in the area and again some of the men serving were celebrities, such as the well-known war poets Wilfred Owen and Edward Thomas.

Although Romford did have a number of old and interesting buildings, many of which were lost in the 1960s and 1970s when much of old Romford vanished due to the ring road that was built around the town. Laurie Square and Laurie Hall both vanished and the road that had always run through the market disappeared. What was once a magnificent football and speedway venue has also vanished, leaving what was once a well-known amateur football team without a permanent home. In the more recent past other old buildings have been lost too, such as the workhouse and most of the brewery.

When you look closer at the town you soon realise that the majority of older buildings that have survived are public houses, such as the Golden Lion, the Lamb and the White Hart, although this is now closed and almost derelict so may also not be around for much longer. Despite this, there is still a lot to see in Romford. With this small book to guide you, and a little imagination, it is possible to imagine the sights and the people who have populated this town and see where those who went on to make history once lived.

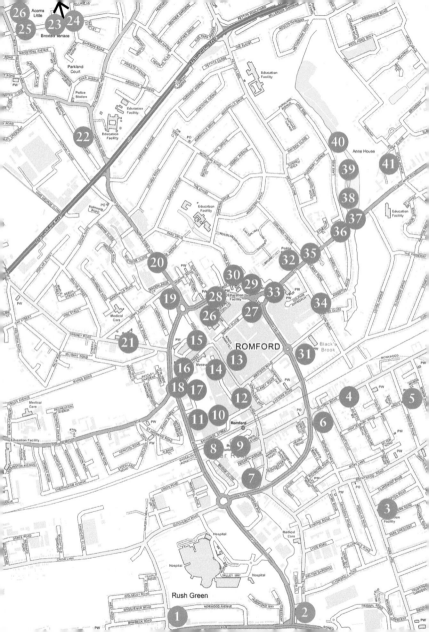

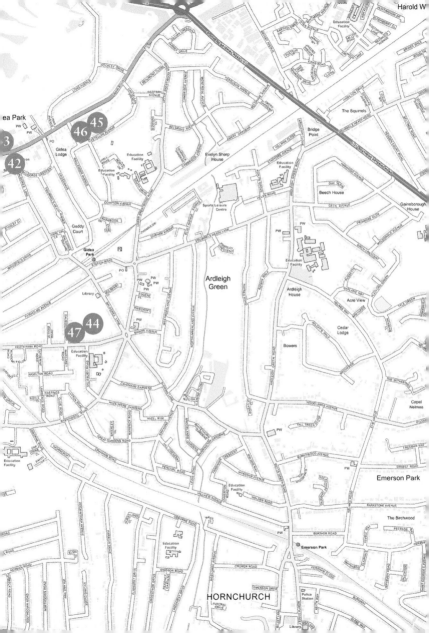

KEY

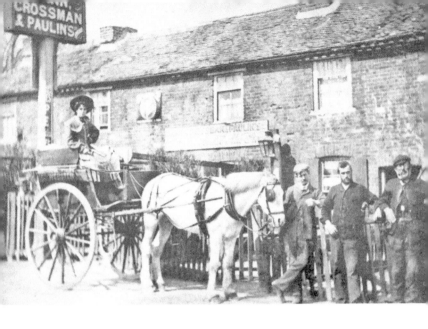

1. COOPER'S ARMS

This photograph shows the Cooper's Arms public house in Rush Green in the early part of the twentieth century. Rush Green was once no more than a small hamlet between Romford and Dagenham. The pub was still known as the Cooper's Arms in the 1970s but has changed names a few times since; it is now the Havering Well.

2. RONEO

There were a number of industries that worked through the war to produce items essential to the war effort, and one of these was Roneo. The Roneo factory stood on the site for so long that it is still known as Roneo Corner even though the factory has gone. Roneo was later taken over by Vickers and the flats that now stand on the site are called Vickers House.

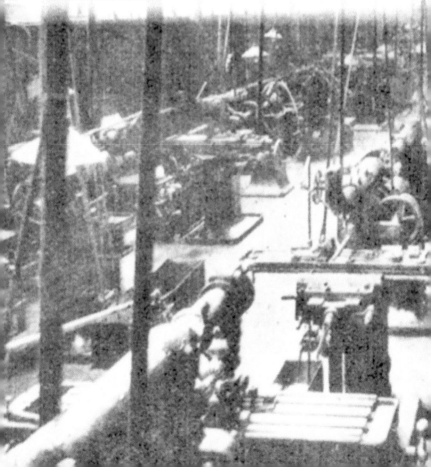

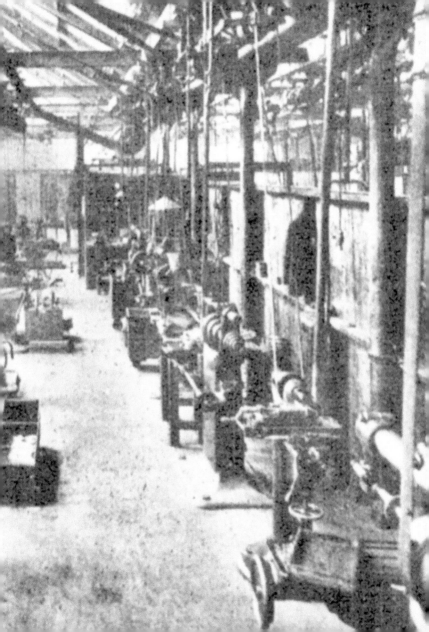

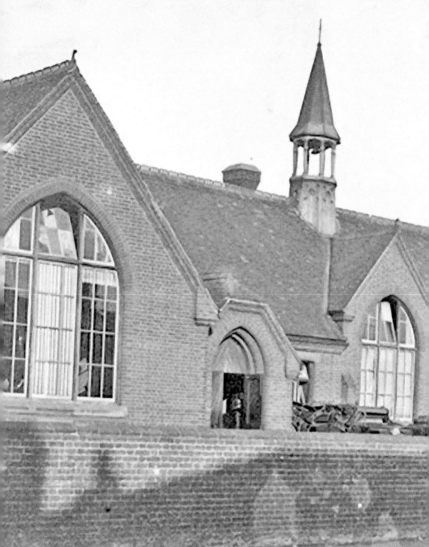

Park Lane School R

3. PARK LANE SCHOOL

A number of schools in Romford were used to billet troops during the First World War. The one shown here is Park Lane School, with some of the soldiers who were based there. The building is still used for education but is now the Raphael Independent private school. (Havering Local Studies Library)

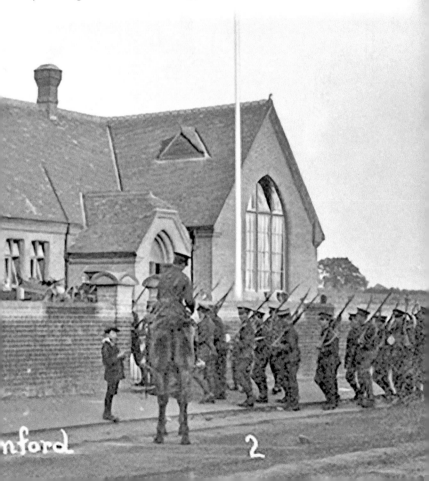

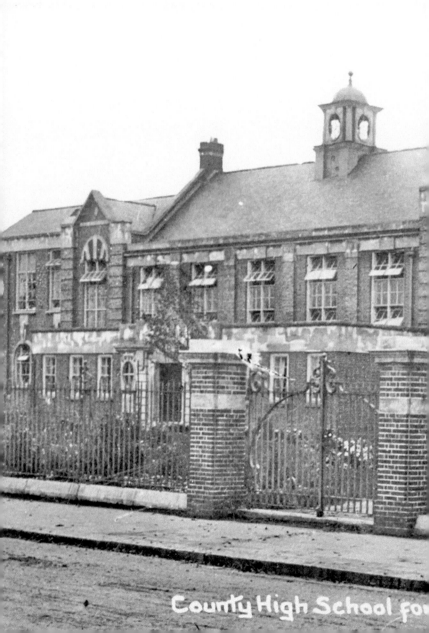

County High School fo

4. ROMFORD COUNTY HIGH SCHOOL

The County High School for Girls was opened in 1910 in Heath Park Road. It later became part of Frances Bardsley School, which had another building in Brentwood Road. This part of the school in Heath Park Road has now closed and been converted into flats.

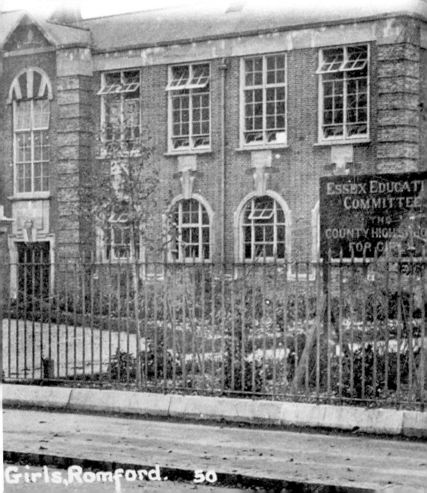

Girls, Romford. 50

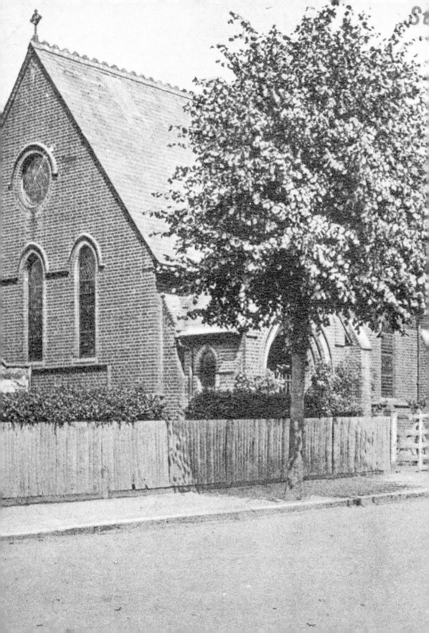

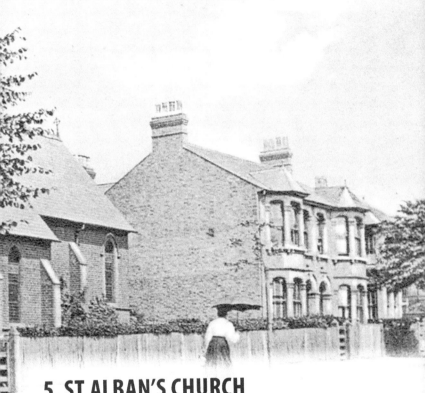

5. ST ALBAN'S CHURCH

The church that is in King's Road was opened as a mission of St Andrew's Church in Hornchurch in the late nineteenth century. The image is from the early twentieth century. It did not become a separate parish until after the Second World War. With the exception of the cross disappearing from the roof, the building seems to have changed little.

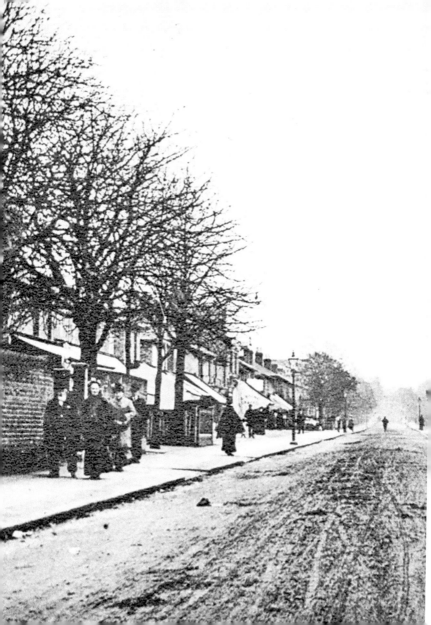

6. VICTORIA ROAD

Victoria Road was one of the more central, built-up areas of the town from an early age. It was, however, mainly residential with some industry. There are still a number of older houses as the road gets further away from South Street, where it is mainly shops.

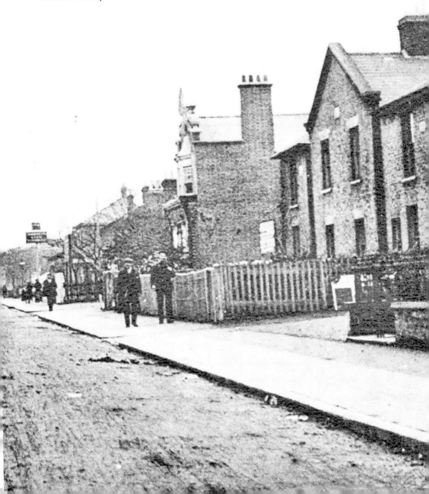

7. SOUTH STREET

During the First World War there were a number of soldiers billeted in Romford. This group are marching along South Street, where some of the older houses still survive, although some were lost to the ring road built in the 1970s. Much of the road is residential until it reaches the town centre. (London Borough of Havering Local Studies Library)

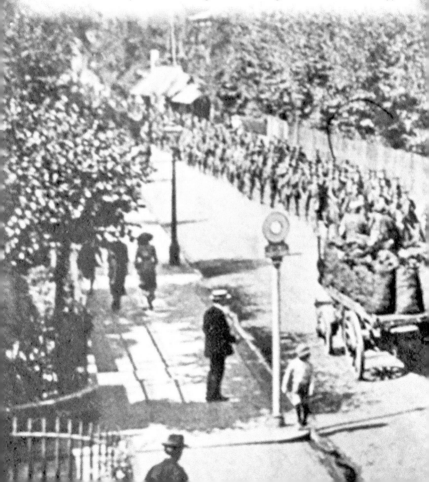

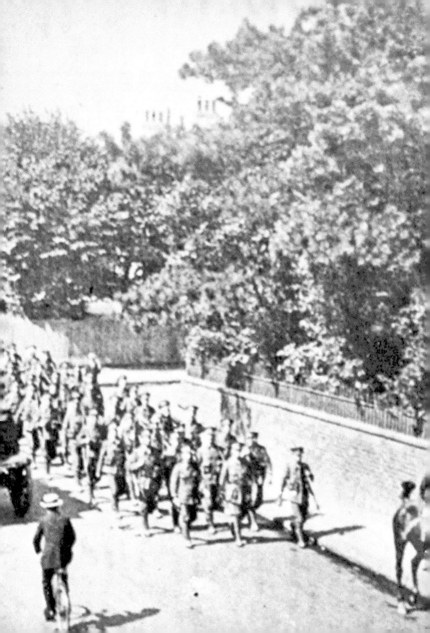

8. ROMFORD STATION

This view of Romford station shows how busy it was in the past.
There seems to be only two platforms for the old steam trains to stop
at. The railway arrived in Romford in 1839 and was responsible for
the great expansion in the area around the town.

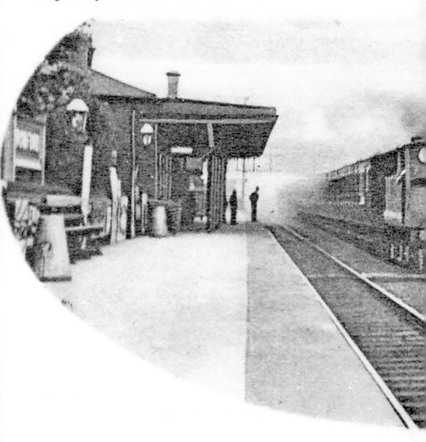

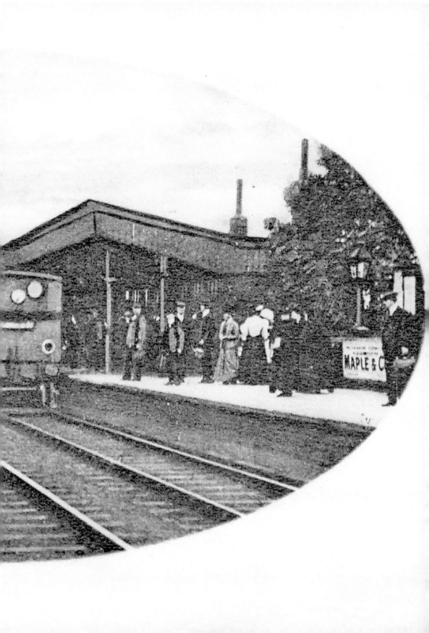

9. SOLDIERS AT THE STATION

The image shows a group of Sikh soldiers at the station during the First World War. Although there were a number of units based in the town at the time, I have been unable to find any record of Indian troops being based there, although there was a large Indian troop camp in the New Forest area. The area beyond the station wall was still very rural at this time. (London Borough of havering Local Studies Library)

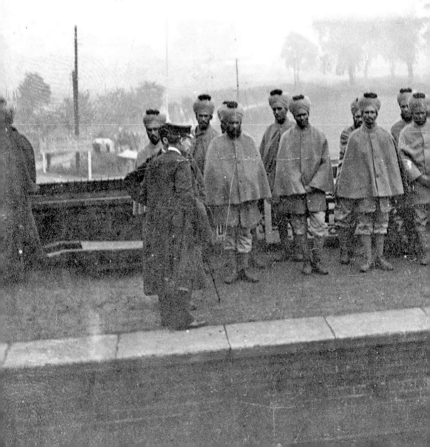

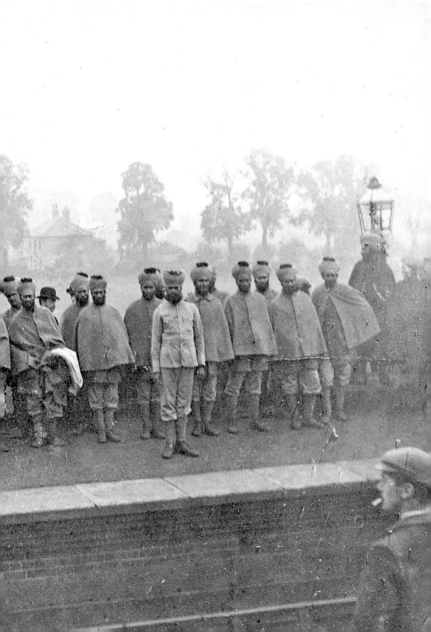

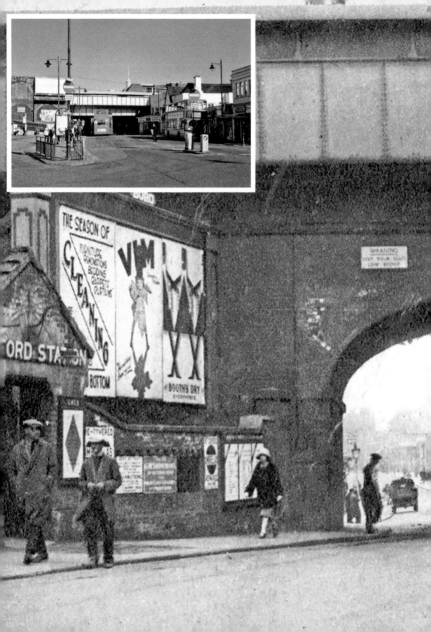

10. THE RAILWAY BRIDGE

This old view of the railway bridge across South Street shows how narrow the road was then. The original station entrance used to be on the right but this photograph shows entrances on both sides of the road. The right-hand one was the access to a separate station, built later to serve a line to Upminster.

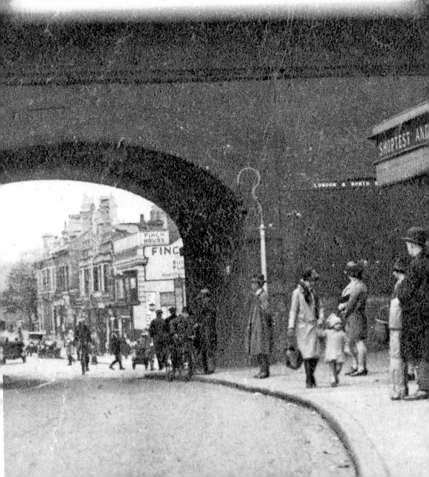

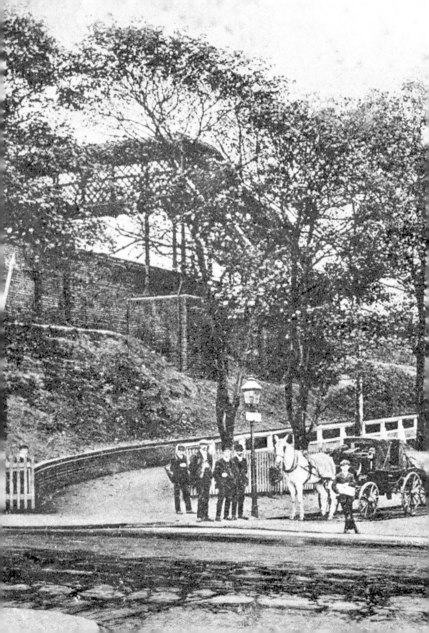

11. STATION APPROACH

When the station was first built at Romford there was an open embankment alongside it. This was obviously where both horse and motor cabs waited for their fares as the passengers got off the trains. The area shown is where the Battis now stands.

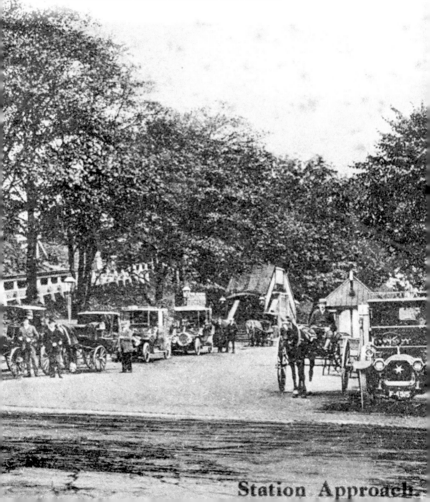

Station Approach

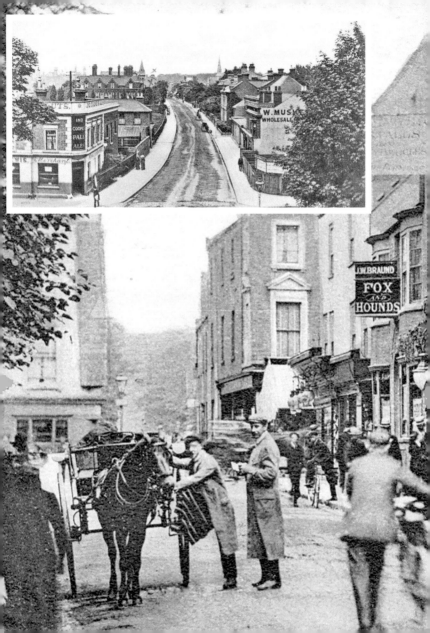

12. SOUTH STREET

This view of South Street shows again how narrow the street once was. The banner advertising a grand summer fête does not seem to have to stretch far between the buildings. I doubt if many of the buildings shown have survived today. The inset shows South Street looking towards the market, with the church spire of St Edward's to the right. The image must have been taken from where the station stands as there is no sign of the railway bridge that has been there since the mid-nineteenth century.

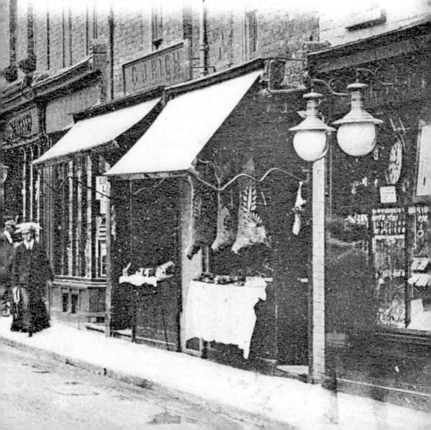

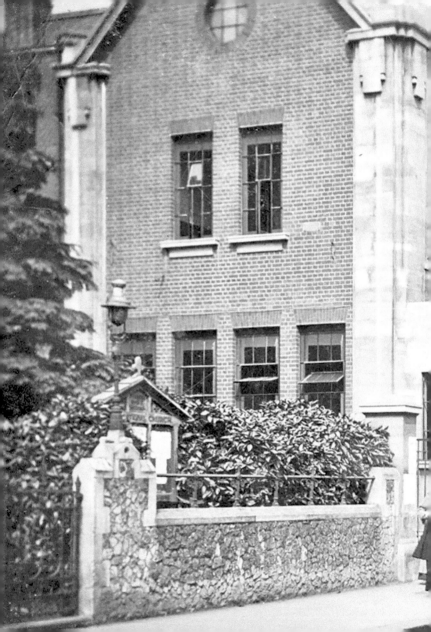

13. THE POST OFFICE

The post office in South Street had a long history. This photograph dates from around the First World War. It lasted as a post office until the recent past when it became a nightclub. This has since closed down and much of the building has been demolished, though the façade of the upper floor is still there.

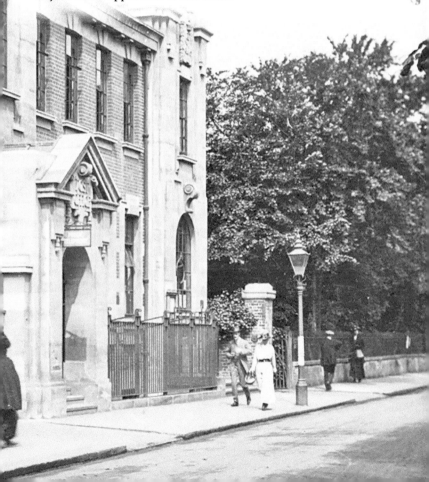

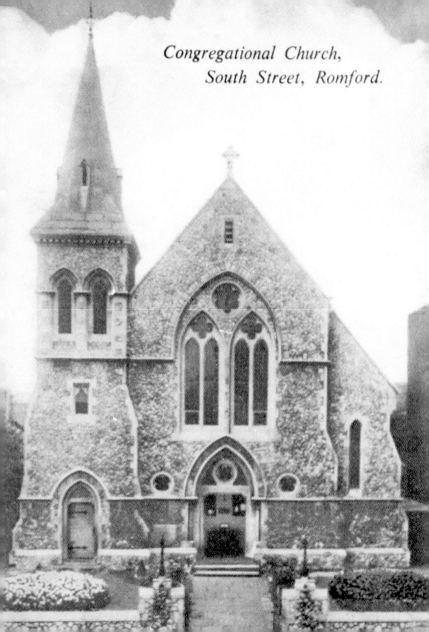

*Congregational Church,
South Street, Romford.*

14. CONGREGATIONAL CHURCH

The Congregational Church stood in South Street and burnt down in 1883. A new one was built immediately and lasted until 1965 when it was sold and a new church was built in Western Road. The image shows the position of the church – it is the spire on the left of the photograph.

15. HIGH STREET

The High Street was one of the more important shopping areas of the town in the past. The Golden Lion is on the extreme right of the photograph and further along on the left is what would have been the brewery buildings.

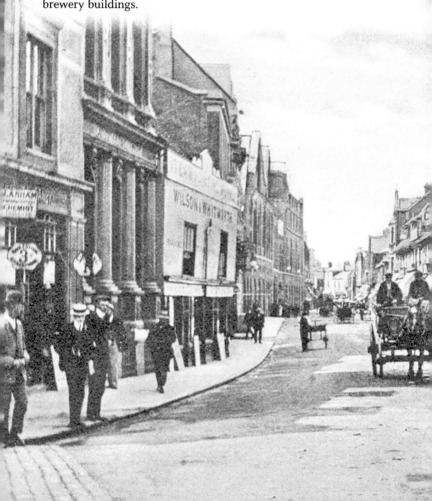

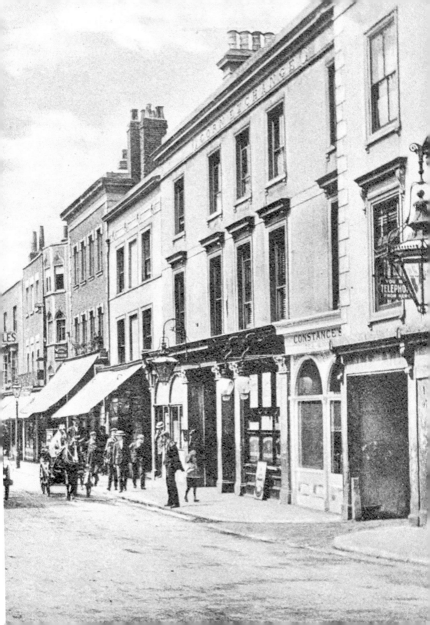

16. HIGH STREET

Another view of the High Street. The building in the centre is the old White Hart public house, which is now closed and partly derelict. It went through a number of name changes and dates back into the history of the town. Another well-known building that stood opposite the White Hart was Woolworths, which has also now gone.

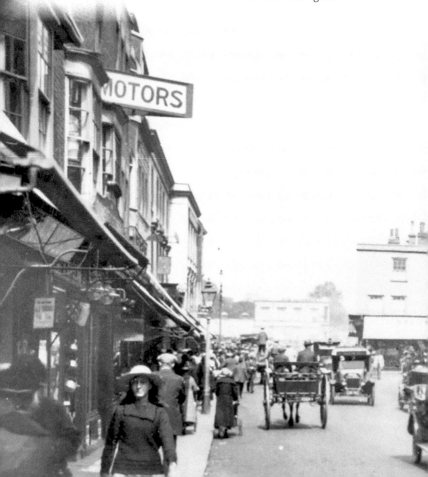

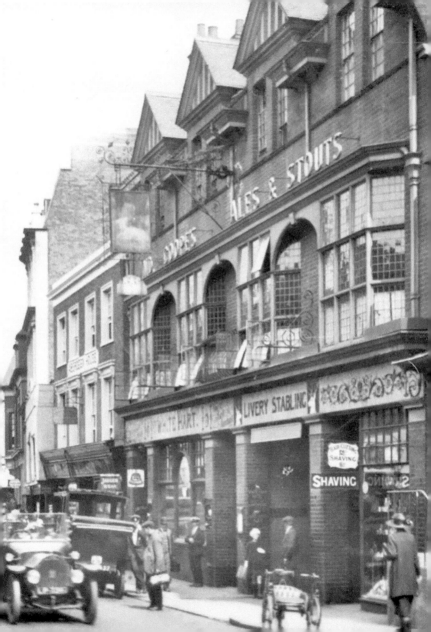

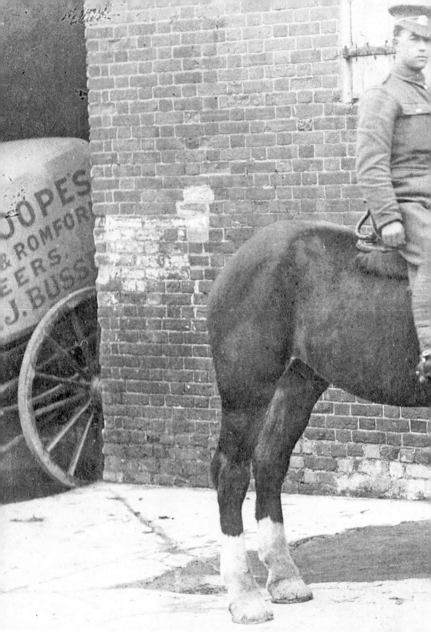

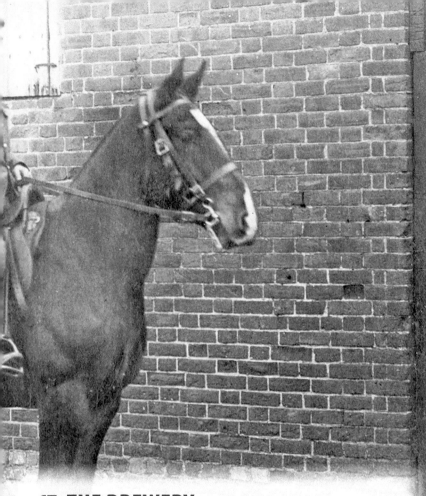

17. THE BREWERY

This image shows a mounted soldier from the First World War. The cart to the left of the mounted soldier is a Romford Brewery cart. No doubt the brewery was a great attraction to the soldiers based in the town.

18. OLD COTTAGES

The photograph shows a row of old cottages that stood in the High Street alongside the brewery. The crowd of people in the image may have been residents of the cottages or perhaps workers in the brewery.

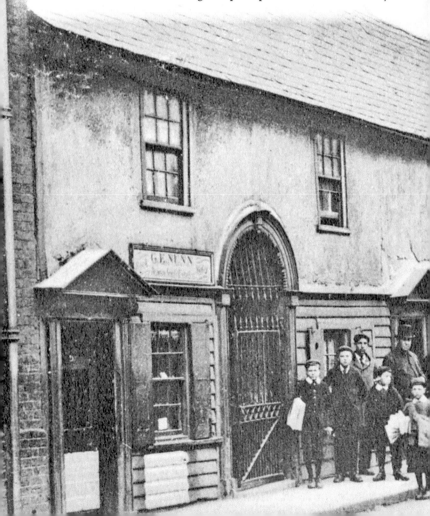

...om old, Cottages adjoining Brewer...

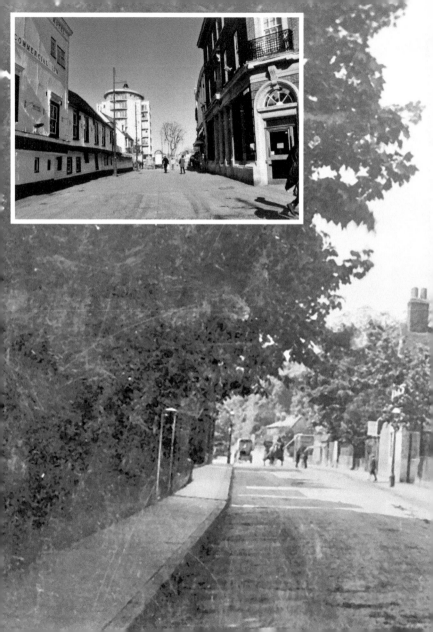

19. NORTH STREET

The image is of North Street in the early twentieth century. It shows Romford Carriage Works, which also dealt with motorcars, as the sign states; however, the transport in the distance seems to be mainly horse powered. There are few of the original buildings left in the street.

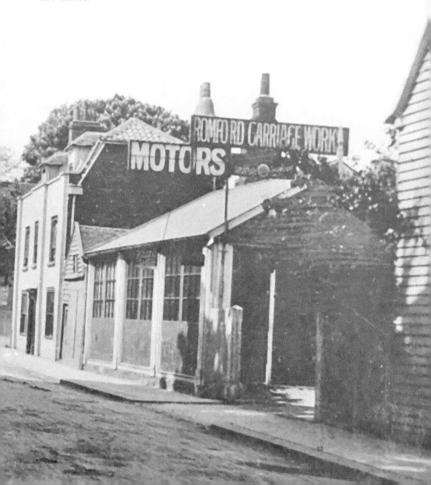

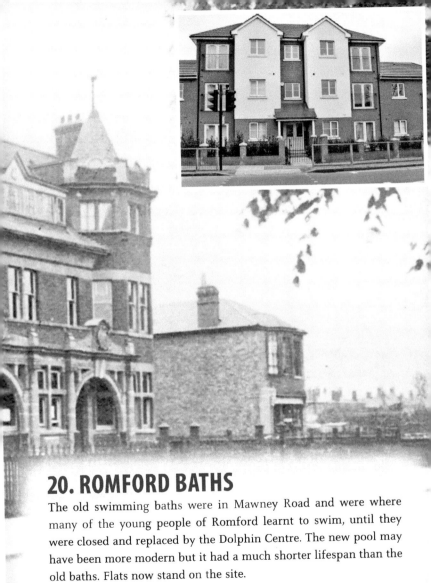

20. ROMFORD BATHS

The old swimming baths were in Mawney Road and were where many of the young people of Romford learnt to swim, until they were closed and replaced by the Dolphin Centre. The new pool may have been more modern but it had a much shorter lifespan than the old baths. Flats now stand on the site.

Lloyd roof insulation
saves £100 per week

Cuts capital spending, too

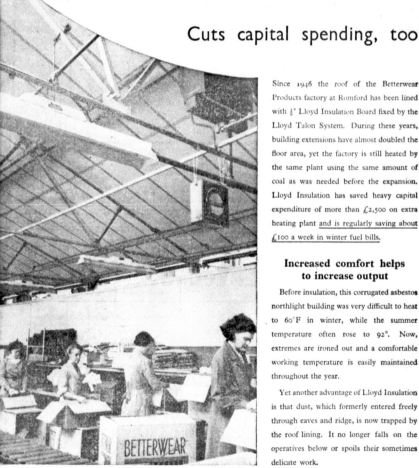

Since 1946 the roof of the Betterwear Products factory at Romford has been lined with ½" Lloyd Insulation Board fixed by the Lloyd Talon System. During these years, building extensions have almost doubled the floor area, yet the factory is still heated by the same plant using the same amount of coal as was needed before the expansion. Lloyd Insulation has saved heavy capital expenditure of more than £2,500 on extra heating plant and is regularly saving about £100 a week in winter fuel bills.

Increased comfort helps to increase output

Before insulation, this corrugated asbestos northlight building was very difficult to heat to 60°F in winter, while the summer temperature often rose to 92°. Now, extremes are ironed out and a comfortable working temperature is easily maintained throughout the year.

Yet another advantage of Lloyd Insulation is that dust, which formerly entered freely through eaves and ridge, is now trapped by the roof lining. It no longer falls on the operatives below or spoils their sometimes delicate work.

21. BETTERWEAR

Part of North Street has always been industrialised and one of the larger factories in the street was Betterwear. They were brush manufactures and most of their employees seemed to have been women. The factory no longer exists and is now the site of a large Matalan store.

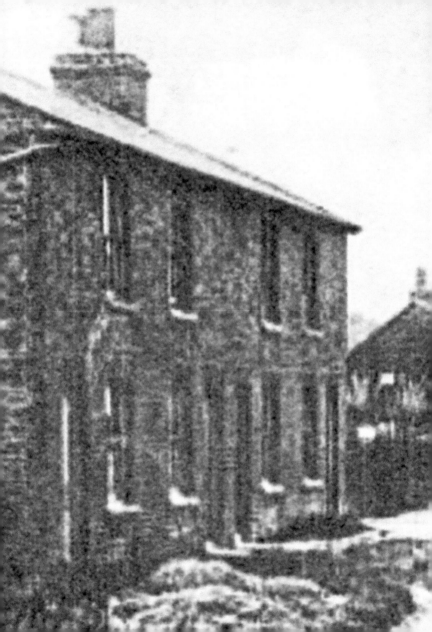

22. COLLIER ROW

The few houses shown in this photograph of Collier Row must date to the early part of the twentieth century. Although they were built earlier than this, Collier Row was developed from the 1920s, with Romford spreading northwards. Despite this the area still retains its rural atmosphere to a certain extent with a lot of open countryside.

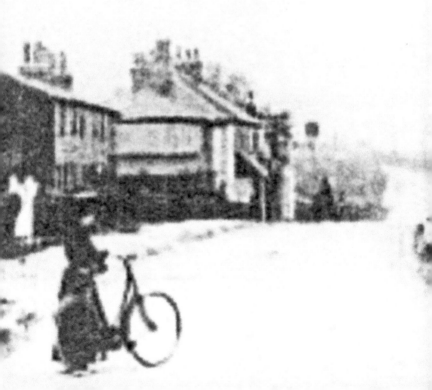

23. COLLIER ROW CHURCH

The church shown in the photograph is the Chapel of the Ascension. There was originally a mission on the site, which had been paid for by a Mr E. Condor. As well as being a chapel, it also had a reading room. The present church was built in 1886 and is now the Anglican Church of the Ascension.

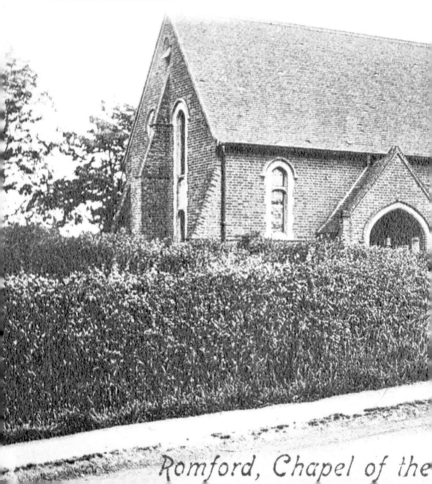

Romford, Chapel of the

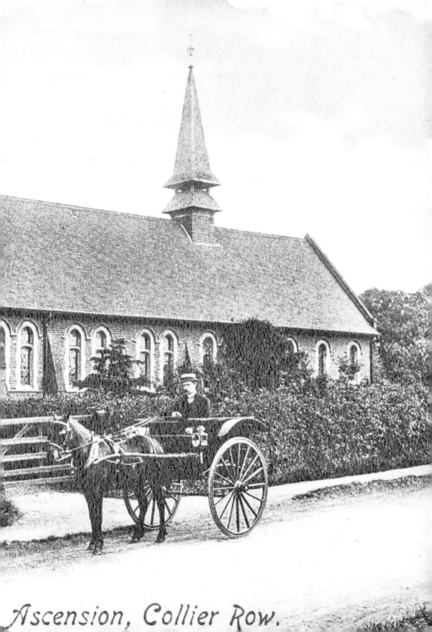

Ascension, Collier Row.

24. COLLIER ROW VILLAGE

The photograph shows Collier Row as a remote village; there are only a few houses along the lane from the church looking towards Hainault Forest. Today it is very different with both sides of the road built up. Very few of the houses shown here survive.

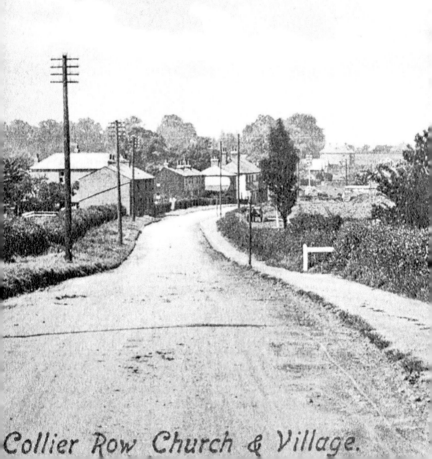

Collier Row Church & Village.

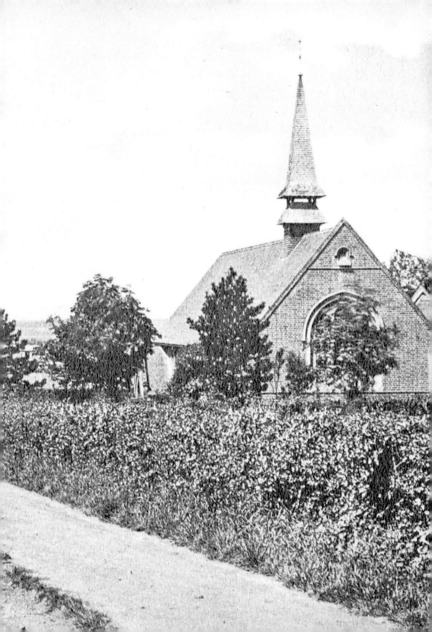

25. THE BELL INN

Ladies on bicycles seem to have been a popular subject for old images of Collier Row. The Bell Inn stood in Collier Row Lane before it was developed. Cycling was a fashionable pastime of the period. No doubt many cyclists would have stopped off at the country inn for refreshment.

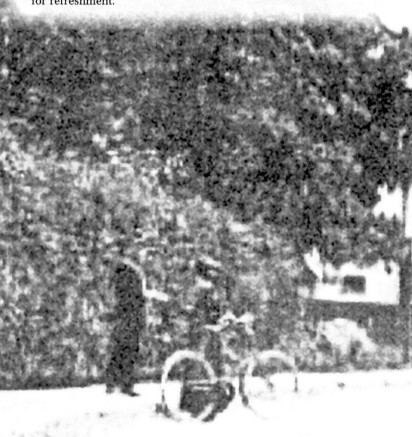

26. RELIEF OF MAFEKING

In 1900 the Boer War was being fought in Africa. The Boers had besieged the town of Mafeking and the relief of the town in May led to a great deal of celebration in England. In Romford this led to a large crowd turning out in the marketplace to celebrate. It seems that the people felt more in tune with the conflicts the country was involved in at that time. (London Borough of Havering Local studies Library)

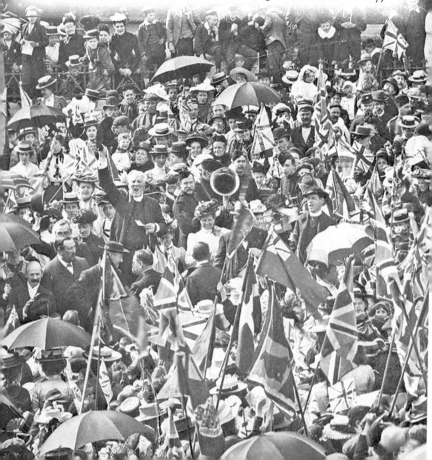

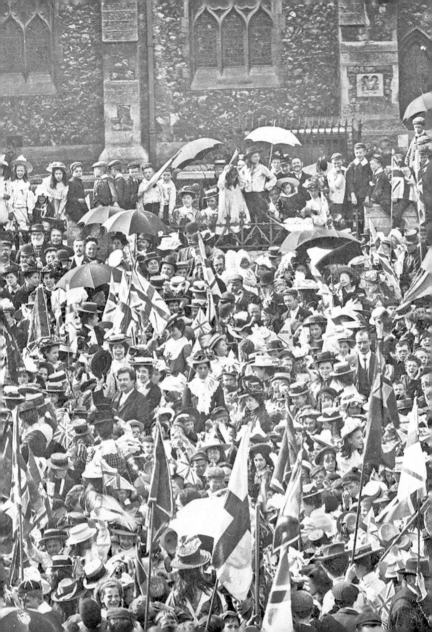

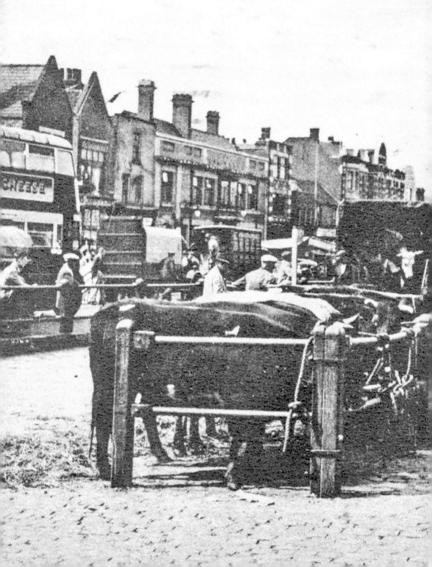

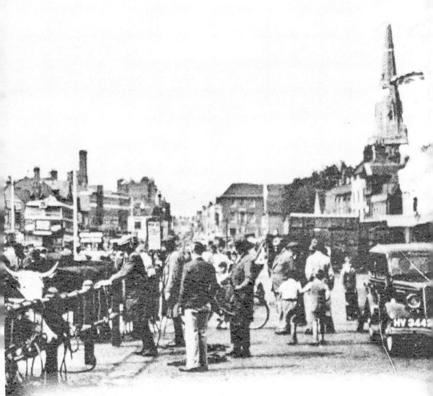

27. CATTLE MARKET

Romford Market was originally a livestock market and the photograph shows when cattle were still sold there. On the far left you can see a bus. There was once a road running through the marketplace, which must have given the bus passengers an interesting view from the windows.

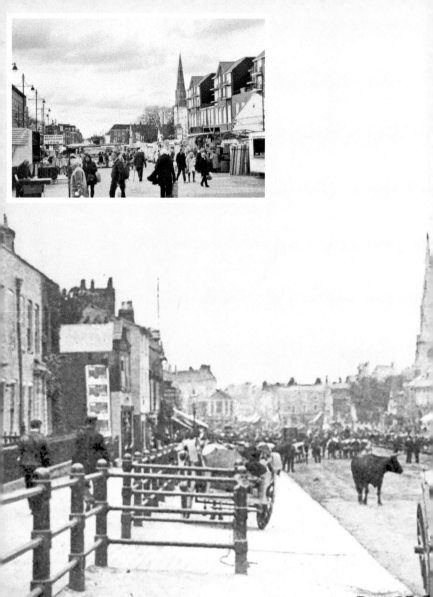

ROMFORD, MARKET PLACE, E

28. ROMFORD MARKET

Another old view of the marketplace. This one shows the old Laurie Hall, which was once Romford Town Hall and later became a cinema. Very few of the buildings shown in this old photograph have survived until today. There are no more than a handful that are more than 100 years old.

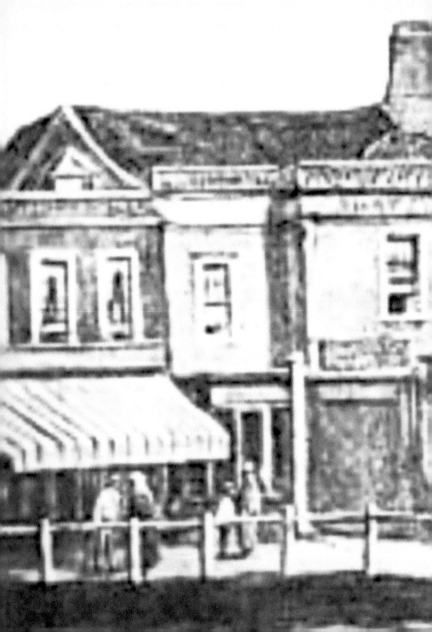

29. THE LAMB

The Lamb public house in the marketplace is one of the older buildings to have survived; the Lamb dates from the early nineteenth century. Not only is it still in this location, it is still also a public house. It is worth noting that many of the old buildings that have survived in Romford are public houses.

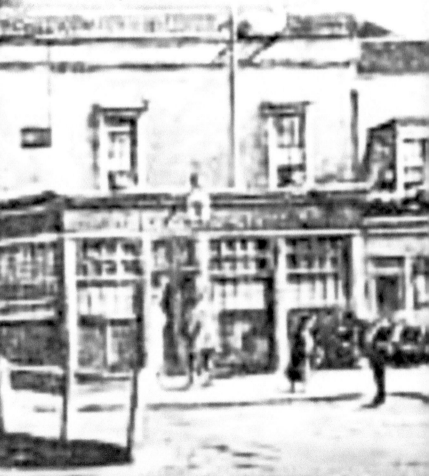

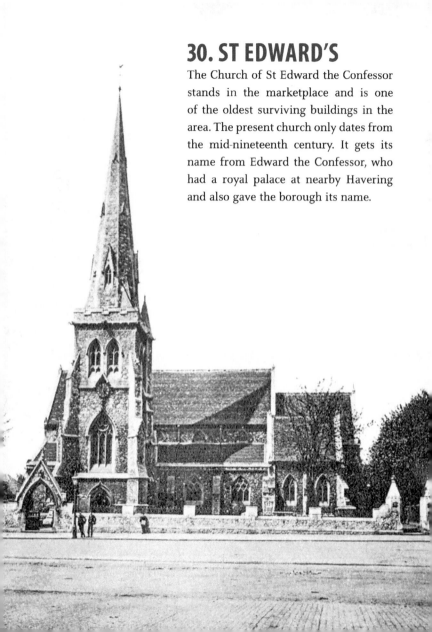

30. ST EDWARD'S

The Church of St Edward the Confessor stands in the marketplace and is one of the oldest surviving buildings in the area. The present church only dates from the mid-nineteenth century. It gets its name from Edward the Confessor, who had a royal palace at nearby Havering and also gave the borough its name.

31. THE TOLL GATE

The photograph shows the west side of Laurie Hall, which stood at the east end of the marketplace, where the road ran through towards Gallows Corner. There used to be an old toll gate on the site where the subway under the ring road now stands.

32. LAURIE SQUARE

After the Second World War, the Essex Regiment was awarded the Freedom of the Borough. The ceremony took place in Laurie Square where the war memorial stood, surrounded by a number of large houses. The square vanished when the ring road was built and was where the library now stands. (London Borough of Havering Local Studies Library)

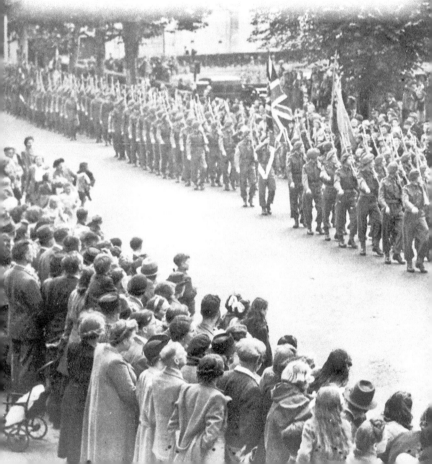

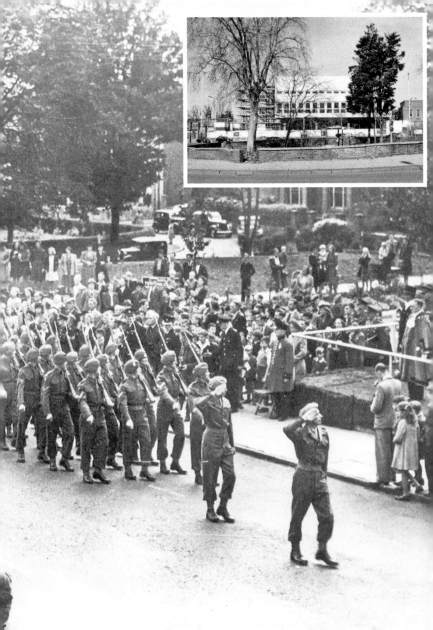

33. THE LIBERTY ARMS

The Liberty Arms public house once stood in Waterloo Road at the turn of the twentieth century. It would have no doubt been popular with the men at the Napoleonic cavalry barracks, which was where the road got its name. The name has not completely disappeared, however, as the Liberty Bell public house and hotel has been built in more recent times.

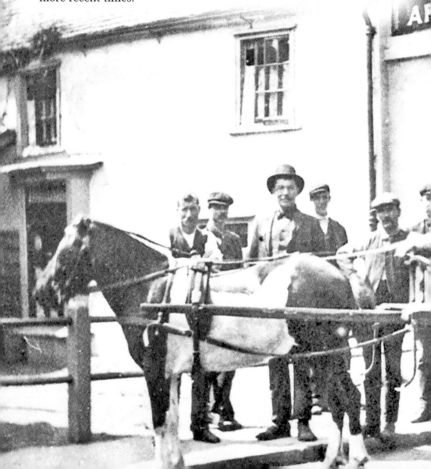

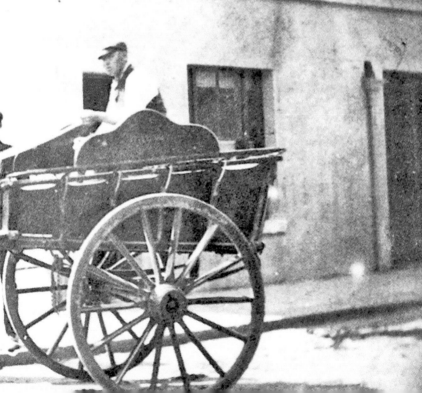

Romford,

34. MASHITER'S CHASE

The photograph shows Mashiter's Chase, which was very rural at the time. The photographer has caught the attention of some young Romford inhabitants. The Chase has now become Junction Road and, along with houses, the back of the Liberty car park is also situated in the road.

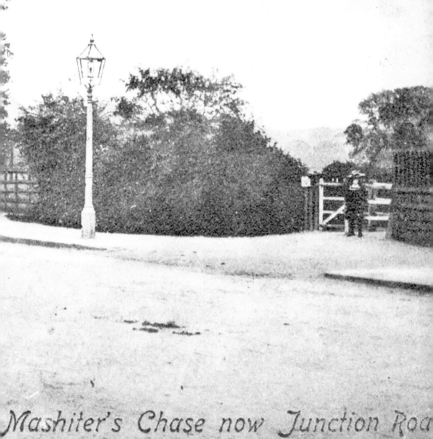

Mashiter's Chase now Junction Road

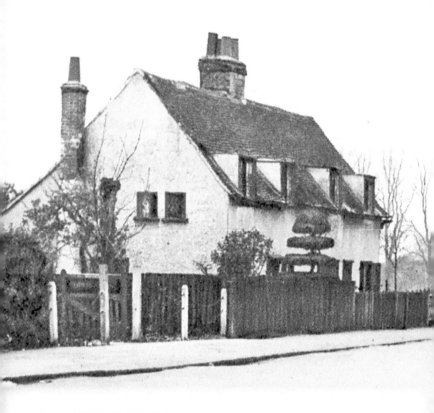

35. MAIN ROAD

An interesting old view of Main Road, which runs from the marketplace to the east of the town and on to Gidea Park. The old bus in the photograph would no doubt be carrying its passengers towards Romford. It also shows some of the large house that line the road.

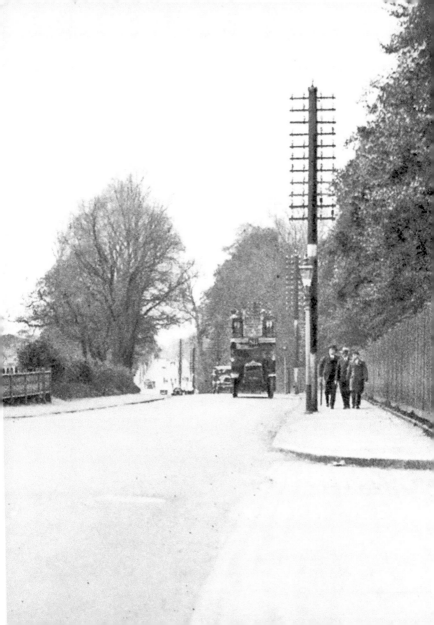

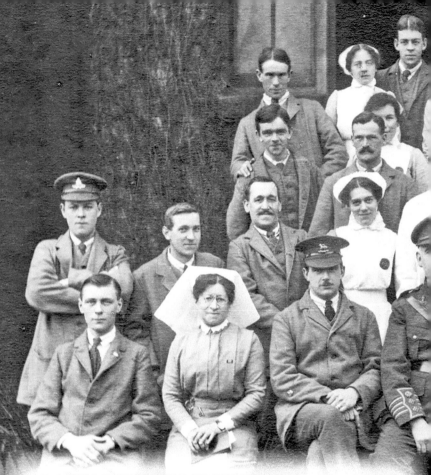

36. WARTIME HOSPITALS

During the First World War a number of large houses were turned into hospitals for the wounded soldiers. This photograph shows some of the wounded and the staff of a hospital in Romford. Unfortunately I don't know exactly where it was, but I suspect that it may have been in one of the large houses on Main Road.

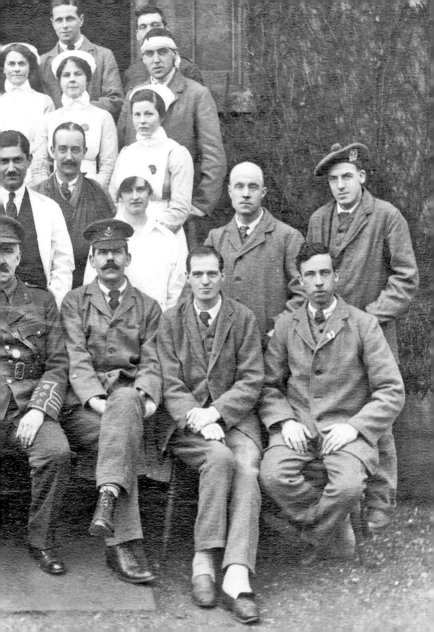

37. BLACK'S BRIDGE

Black's Bridge is now part of Main Road and crosses the lake in Raphael's Park, which was once known as Black's Canal. It was named after a gentleman named Black who owned Gidea Hall around the turn of the nineteenth century, who it seems was unpopular with locals.

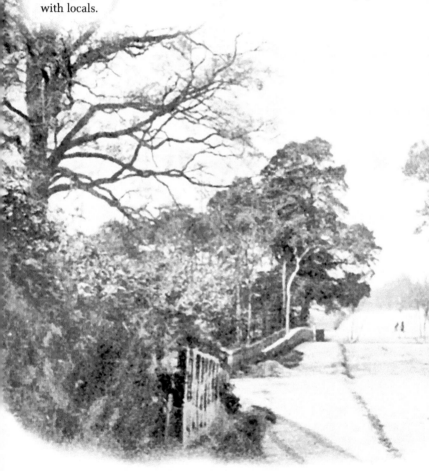

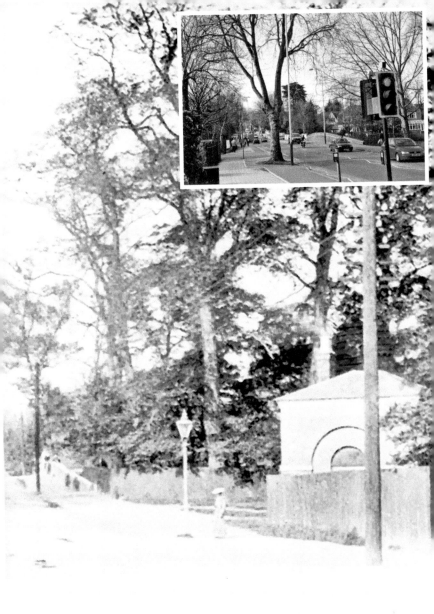

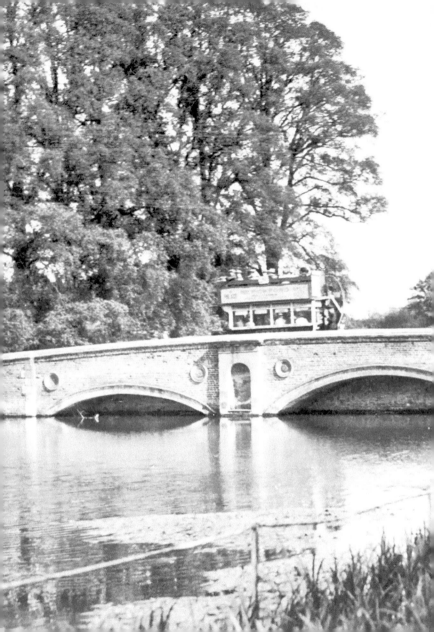

38. BLACK'S BRIDGE

This is another view of the bridge from inside the park – what a fine structure it is. The old bus passing over it indicates that the bridge has stood on an important route for many years and has changed little in that time.

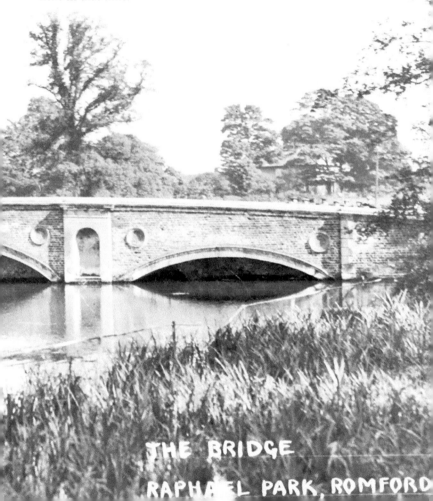

THE BRIDGE
RAPHAEL PARK, ROMFORD

39. RAPHAEL'S PARK

The land for Raphael's Park was presented to the town by the Raphael family, who lived in Gidea Hall around the time of the First World War. It was seen as a concession to the town for allowing Sir Herbert Raphael to build a large housing estate on their land.

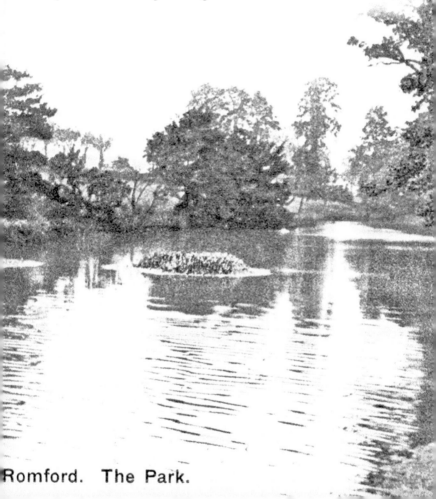

Romford. The Park.

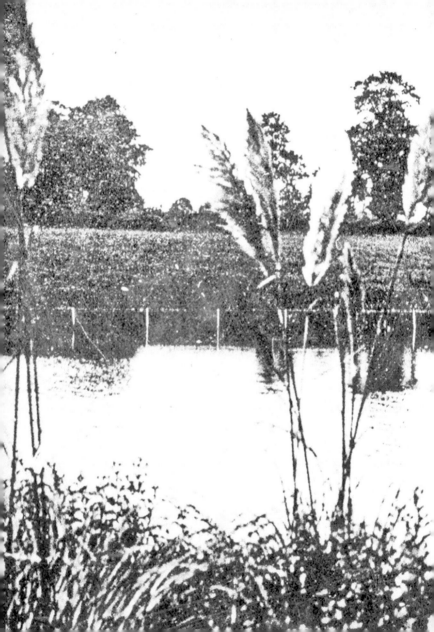

40. RAPHAEL'S PARK

The view of the lake in the park differs greatly to what it looks like today. The western bank of the lake is open ground at this time but is now covered in housing, with back gardens leading down to the lake.

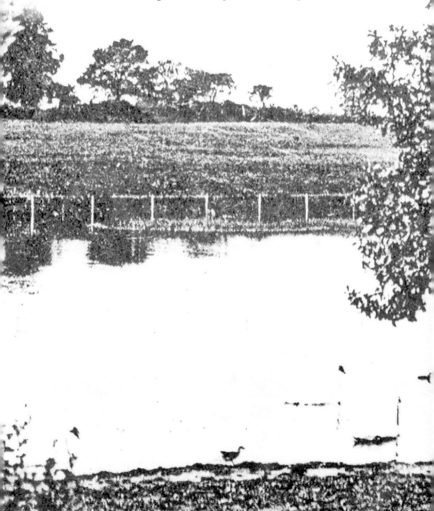

41. THE ROMFORD GARDEN SUBURB

Some houses can be seen here being built on the new estate on the grounds of Gidea Hall. Sir Herbert Raphael, the owner of Gidea Hall, had offered 1,000 guineas in prize money in a competition to design houses that would cost £350 to £500, a large amount in those times. The design of the houses was quite varied in the more expensive roads.

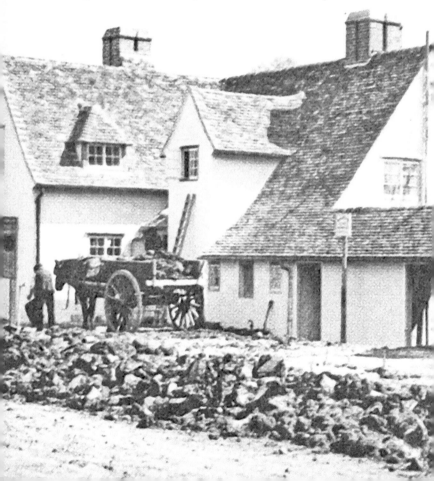

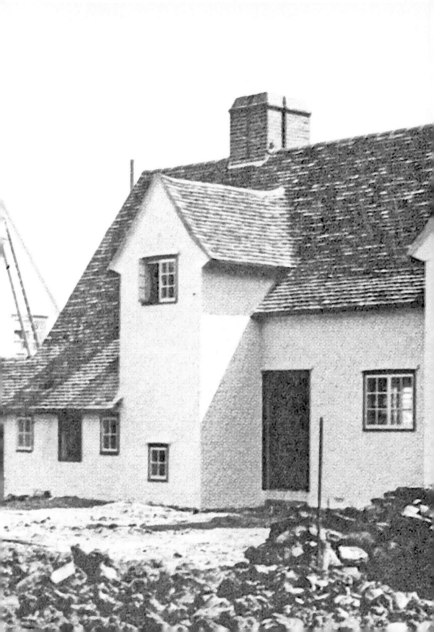

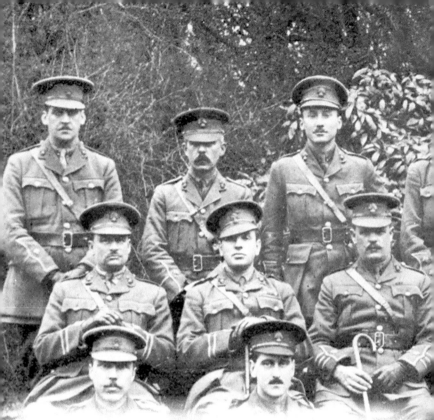

42. HARE HALL CAMP

War broke out soon after the houses were built on the grounds of Gidea Hall, and the nearby Hare Hall became an army camp. One of the first units based there were the Sportsman's Battalion and later the Artist Rifles Officer Training Corps, which included some of the famous war poets. While the men lived in huts at the camp, many of the officers lived in local houses such as the building that is now a nursery school in Balgores Lane. These are officers of the Sportsman's Battalion.

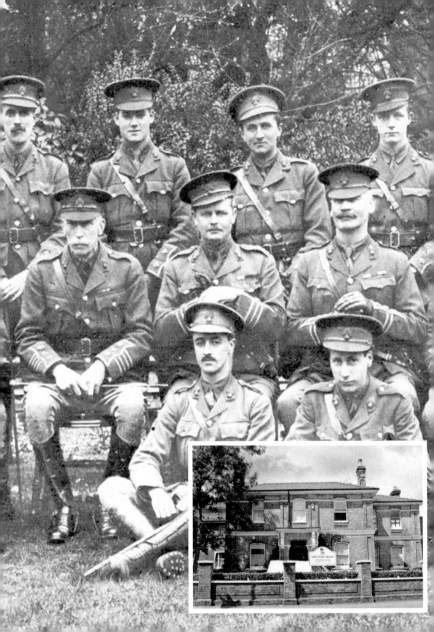

43. HARE STREET

Hare Street was still a rural hamlet in the early twentieth century, and when the soldiers arrived at local camps during the First World War they outnumbered the local population. One of the area's best-known residents in the past was the gardener Humphrey Repton, whose house was where the Lloyds bank building now stands. The inset shows another view of the hamlet of Hare Street in its rural days.

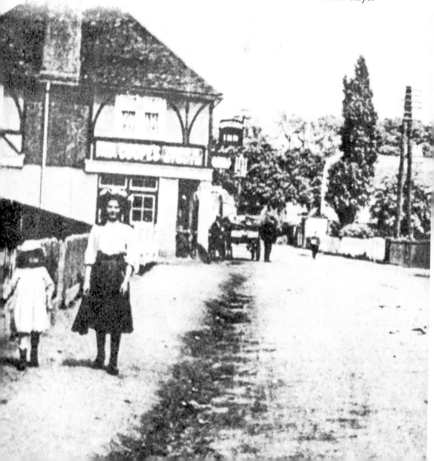

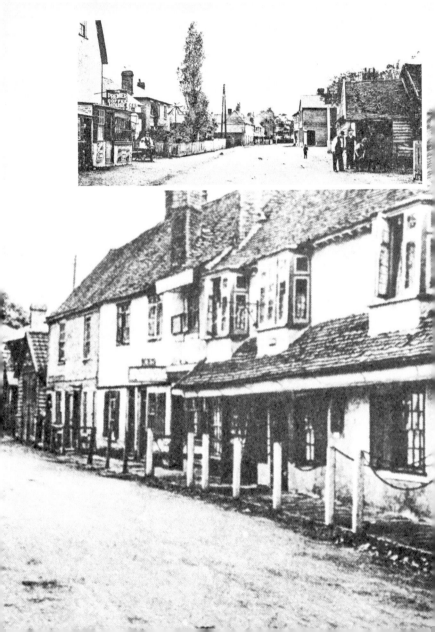

44. THE MILITARY

The open spaces that still existed around Hare Street were ideal for training the troops at such tasks as trench digging. The photograph here shows mobile kitchen units – learning to feed the men was as important as learning how to fight. There is little doubt that some of what remains of open ground close to Hare Street was used by the military.

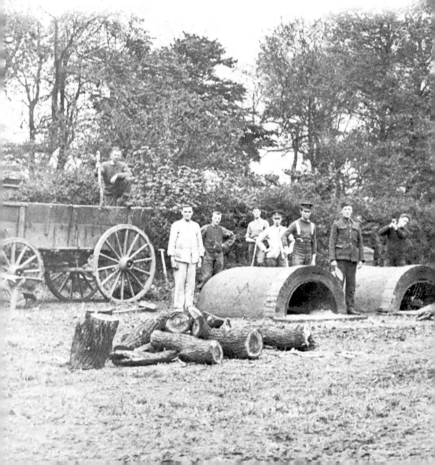

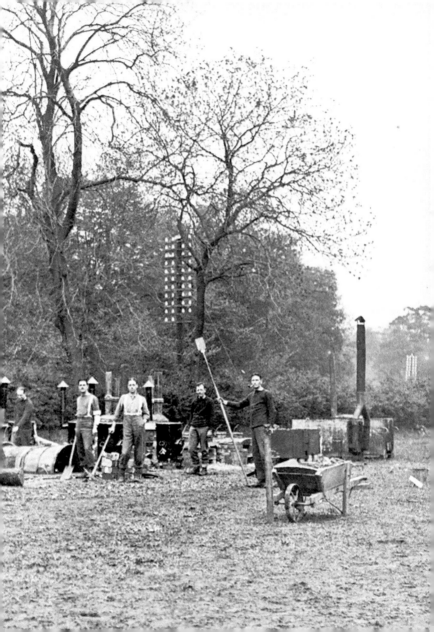

45. HARE HALL

When Hare Hall became an army camp during the First World War, its grounds were covered in wooden huts for units such as the Artist Rifles, whose members included Wilfred Owen and Edward Thomas. They followed the 2nd Sportsman's Battalion, a unit made up of sportsmen and those from the world of entertainment. The hall is now part of the Royal Liberty School. Some of the huts in use at the school may be originally from the camp.

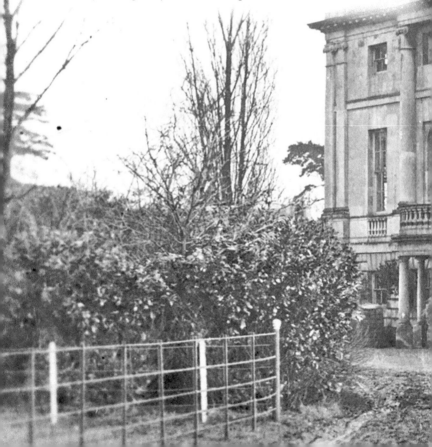

46. THE SPORTSMAN'S BATTALION

Life at Hare Hall camp must have been an unusual experience for the members of the Sportsman's Battalion, many of whom were celebrities and unused to living in such conditions. The men are shown at the camp drilling, noticeably without any weapons.

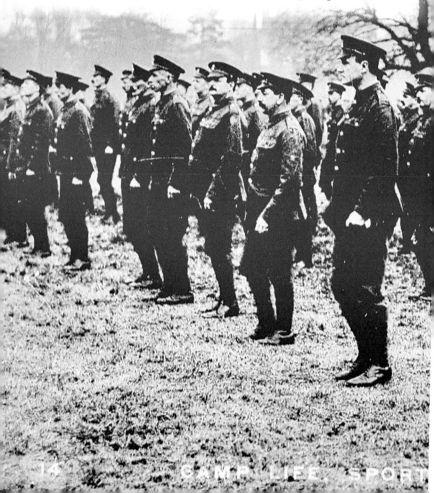